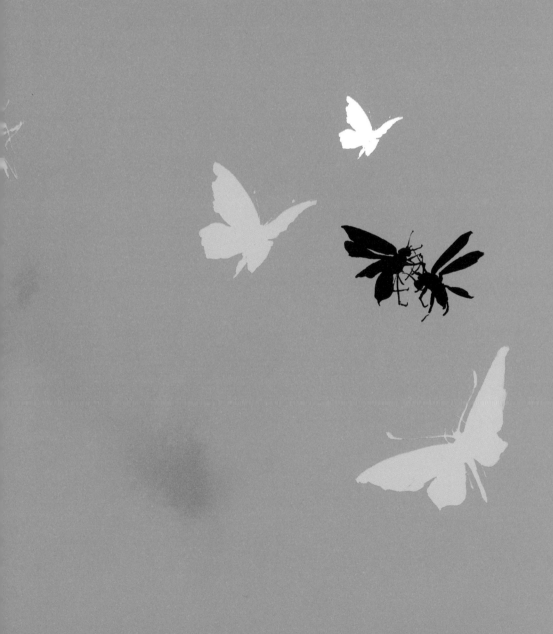

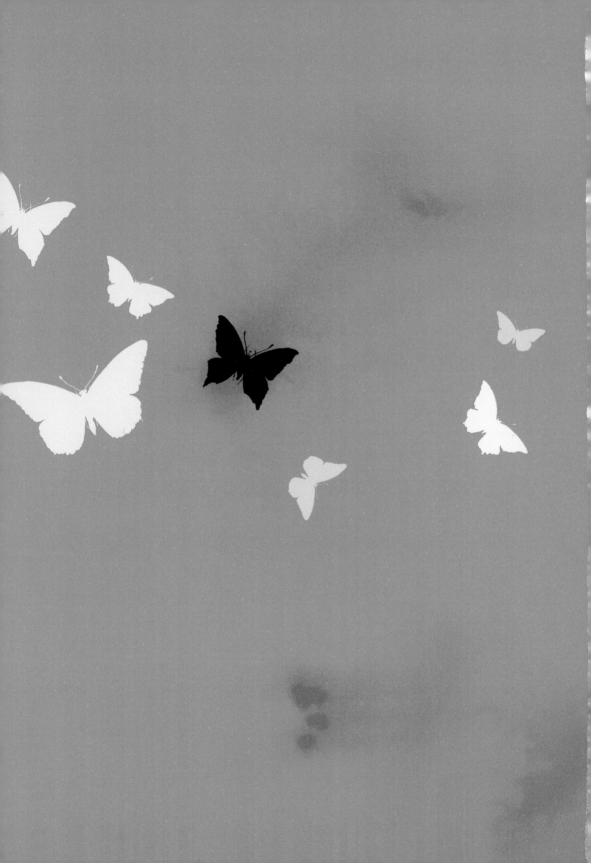

A *Swarm,*
A Flock,
a Host

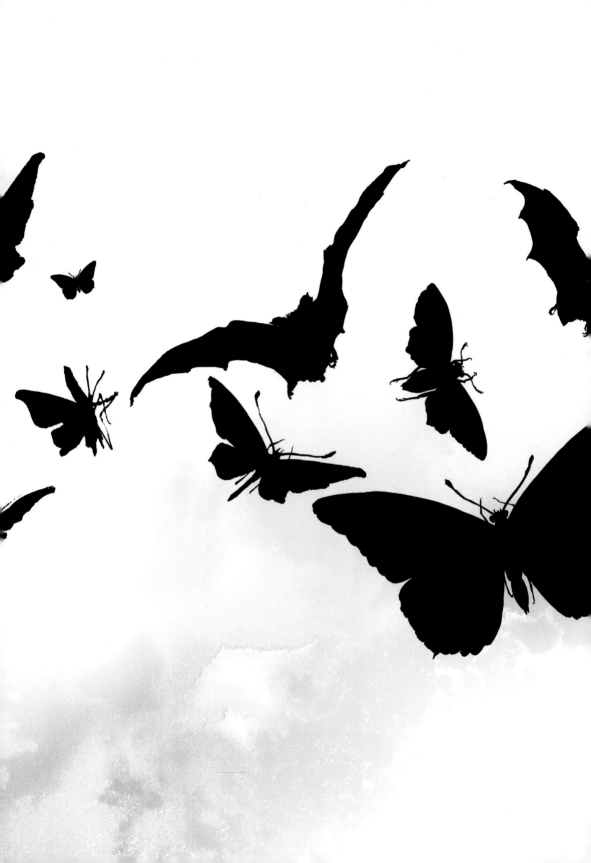

A *Swarm,* *A* Flock, a Host

A Compendium of Creatures

Mark Doty *&*
Darren Waterston

Prestel
Munich · London · New York

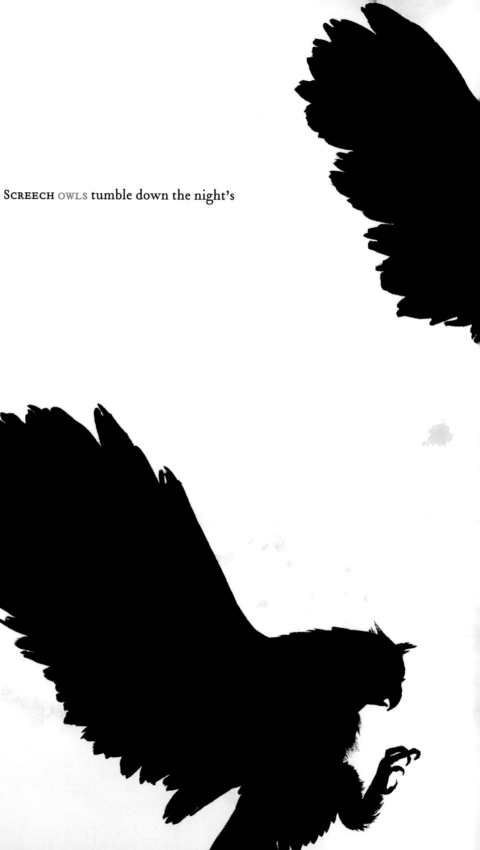

SCREECH OWLS tumble down the night's

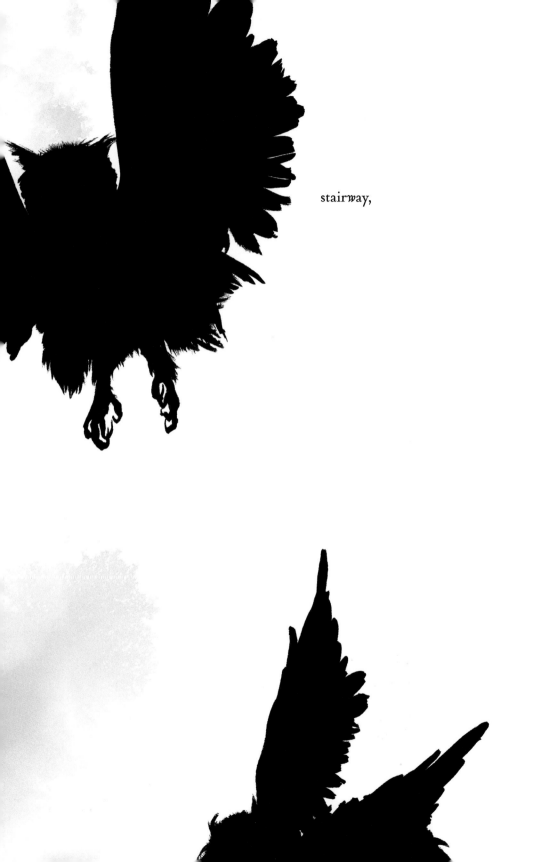

stairway,

the cardinals nail a brilliant point
　　to the morning's argument.

The turkeys lament their fate all day,
　　but no one listens,
the appetite of the ticks swell with the
　　mounting hours,

and su*mm*er rises like a *great* s*w*elling cloud bank,
yellow *j*ackets digging deeper into their
 underground *gl*obe,

swirling and s*w*irling down there
in a buzzing, terrible sphere of threat.

Midday snake hot
on a shelf of stone,

no *frog* talk till dusk,

but the grasshoppers ca*n*'t contain their happiness,
which causes the tight machinery of their bodies
 to *sp*ring forward,

*fu*rther, higher, more ambitious,
though the goats lie down and pant in the hot shade.

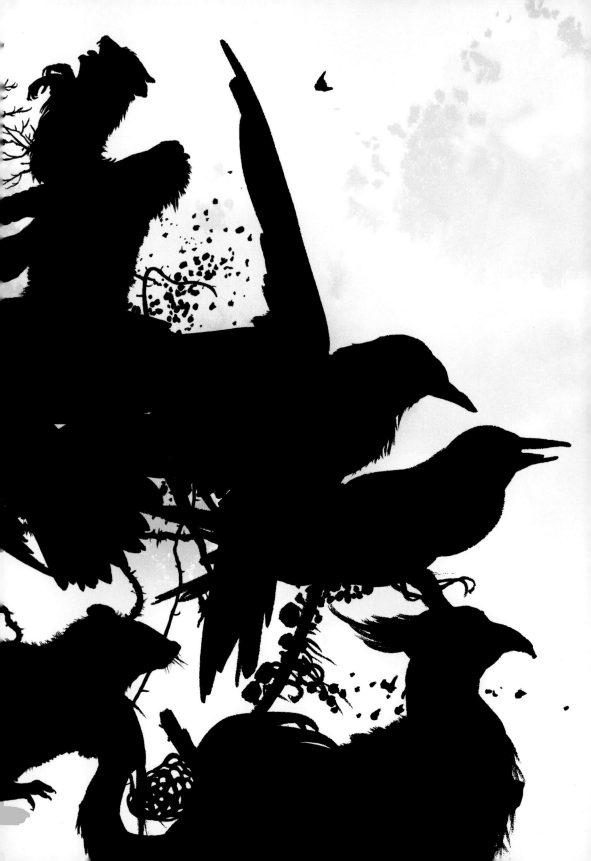

THE WOODPECKER wears on his forehead
a bit of the original *fl*ame

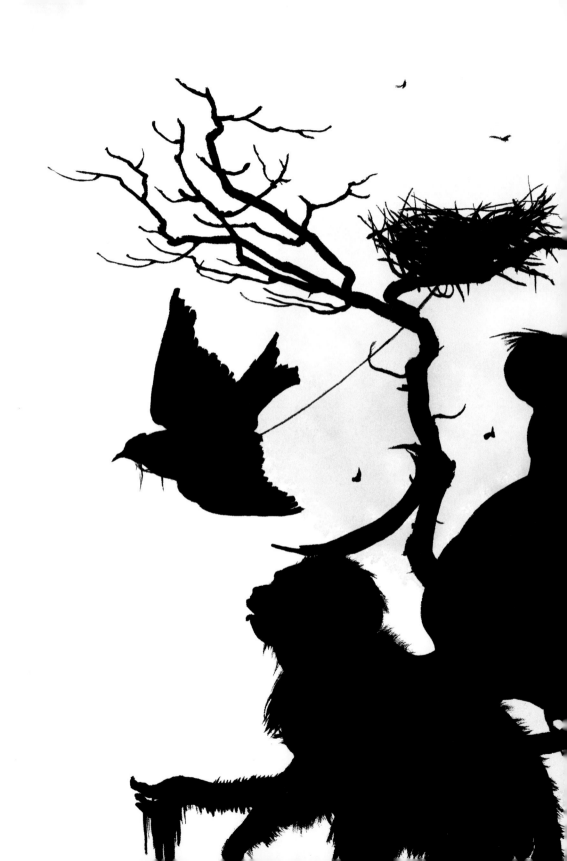

so that he might not forget the conflagration
in which the world began

and the long slow (only to our eyes) burning
whereby it is perpetually consumed.

Hail to fire,
says the outrageous tail of the mandr*ill*;

even in darkness flame is hidden,
reads the subtle tipping

outli*ni*ng the wing of the red-winged blackbird.

THE VERY DOMESTIC DOG, who would not know how to live
 in the city
were it not for the men who love him, and *fill* his bowl,

and *guide* him at the intersection so that he doesn't walk into
the heedless traffic, *stops* still when the ambulance comes

rushing up the street toward him, and tenses his body,
lifts his head a little, and begins to ho*wl* quietly,

matching the pitch of the siren exac*tly*.

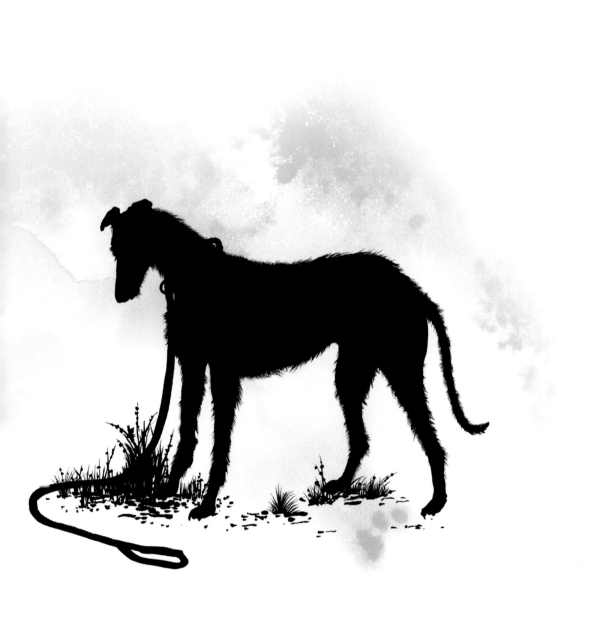

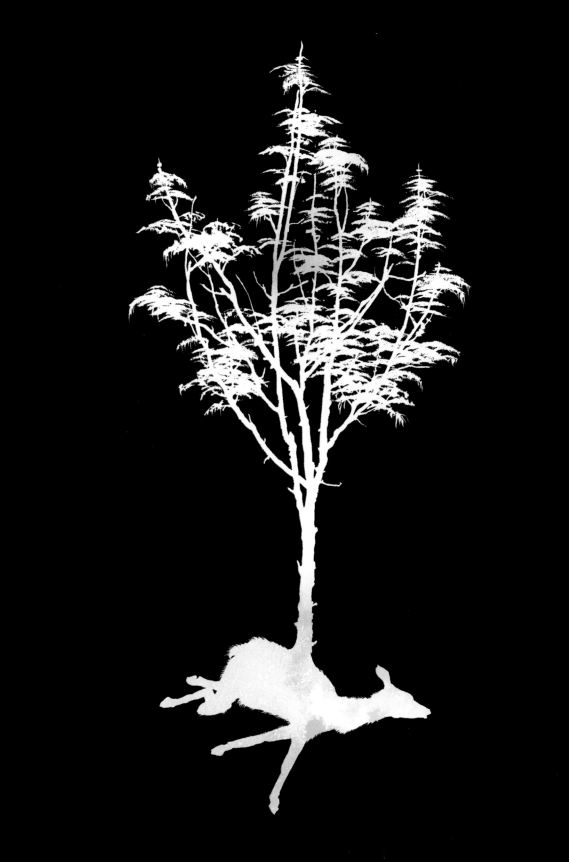

WHEN I FOUND THE DEER'S BODY at the back of the garden,
where it had sunk into the earth beneath the wire fence,

and from it gushed a great fountain of maggots,
horrifying, sickening that fecundity, and yet

it was the stream pouring back into the world,
movement from something to nothing and back again,

descent that passed in blind pain and then swelled out
into the unstoppable current of the new:

all the worlds' dense and disparate populations
filter that music through the singular registers

of their voices, but it's the same terrifying song.

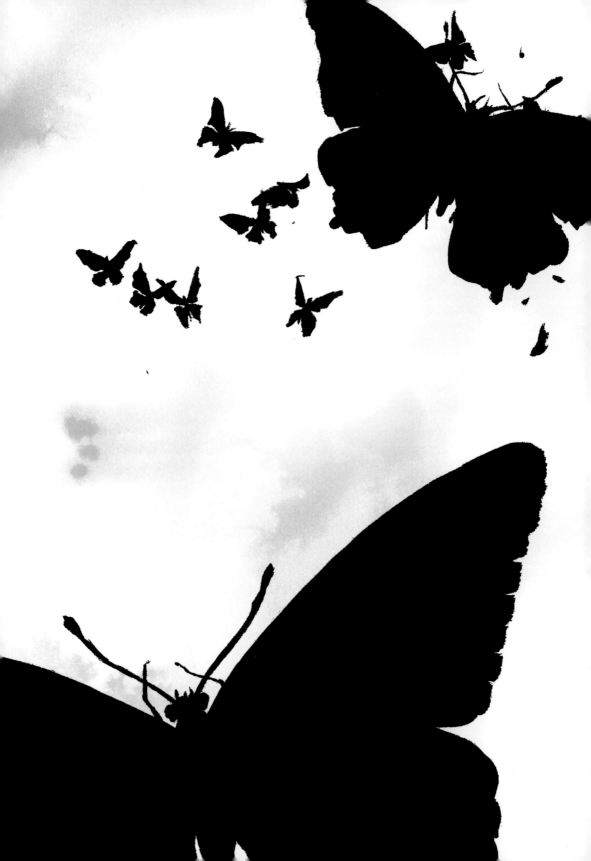

Now there's a presumption:
if you grant

these erratic *ae*rialists character,

think the *monarchs* noble
in their dashing for the stored sunlight

of sugar, well who are you to condemn
the appetites of tinier things?

Cowbirds and catbirds combing the garden,
tossing *as*ide leaves, eyeing the stalks;

hunger piled upon hunger.
Well, says my friend, you have to be a good animal
before *y*ou can be a saint.

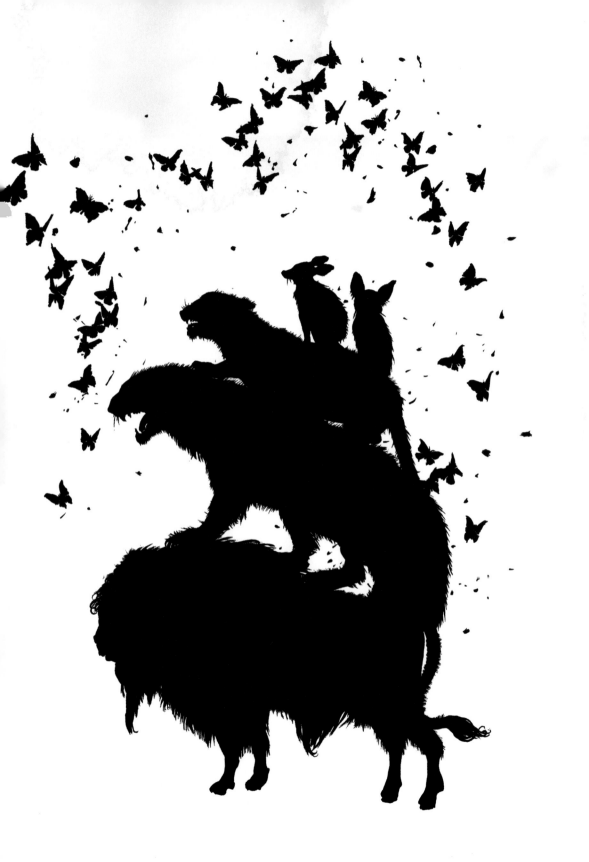

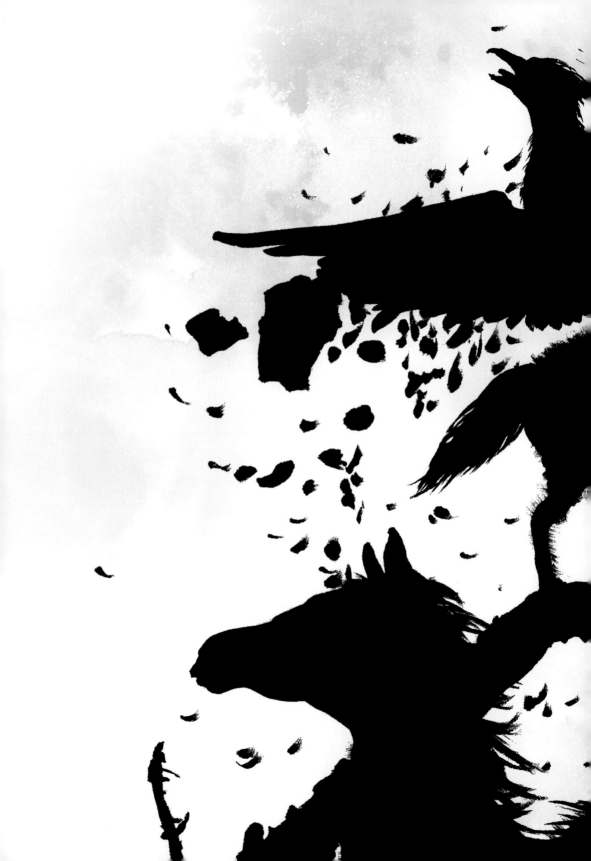

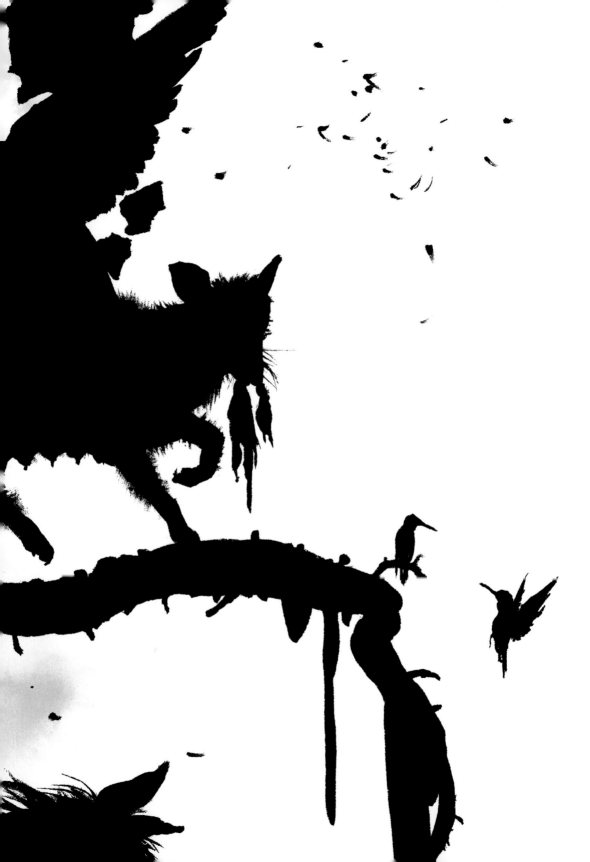

SNAIL

*ex*hales a silver avenue

THE MOLES, who have been deputized by desire,

undermine the solid *foundation* of the day,

while the dogs, who are in the employment of joy,

re*fu*se all seriousness.

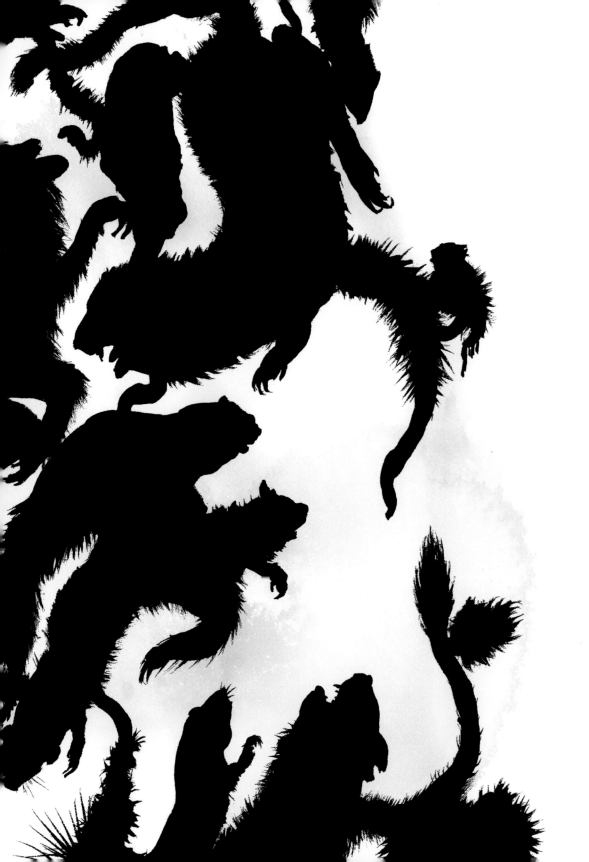

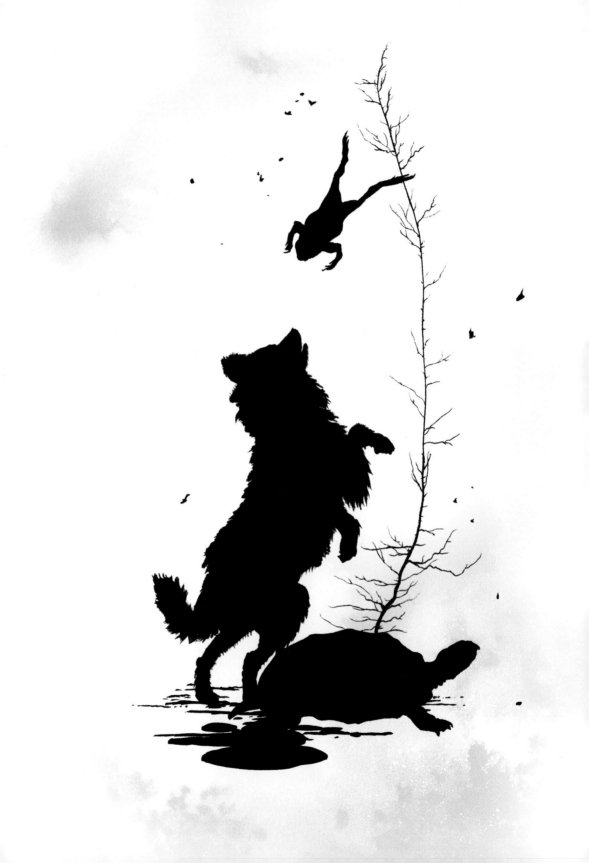

THE DOMESTIC DOG, at six months, walks home
down the rural road rushing at any little
skittering thing, leaf and tuft, bits of dry eelgrass
blowing in from the beach path,

and thus he misses the yellow-spotted, faded tobacco
of the tortoise, who lifts herself
—a finely lacquered loaf of bread—
over the small rise by the ditch and out of sight.

If she's fifty, then she's one hundred times his age.

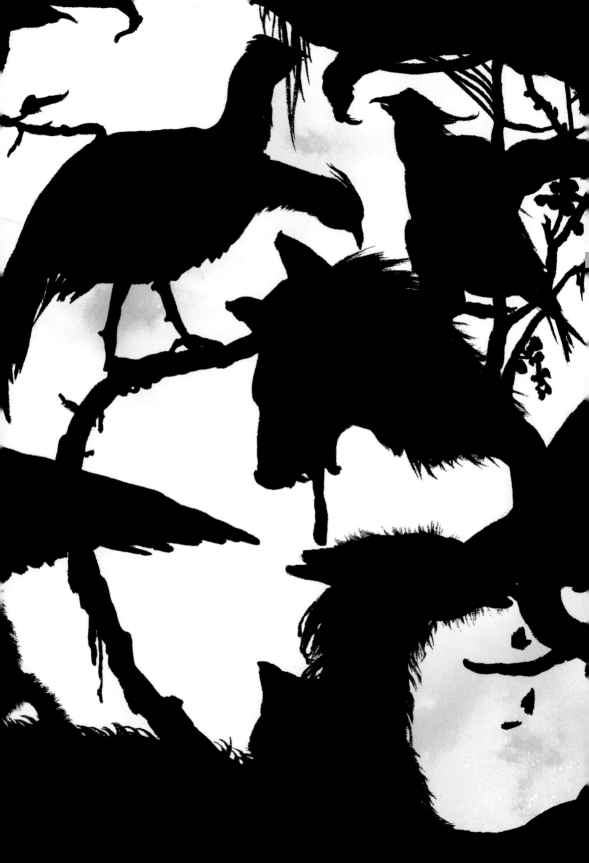

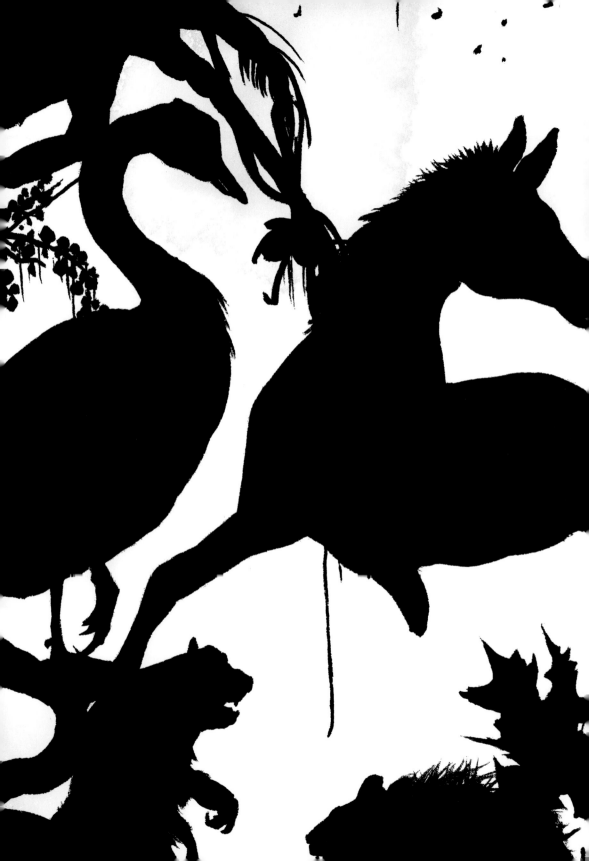

Fox crossing Louse Point Road
dandles her prey in her *mouth*
—something dark, furred, round—

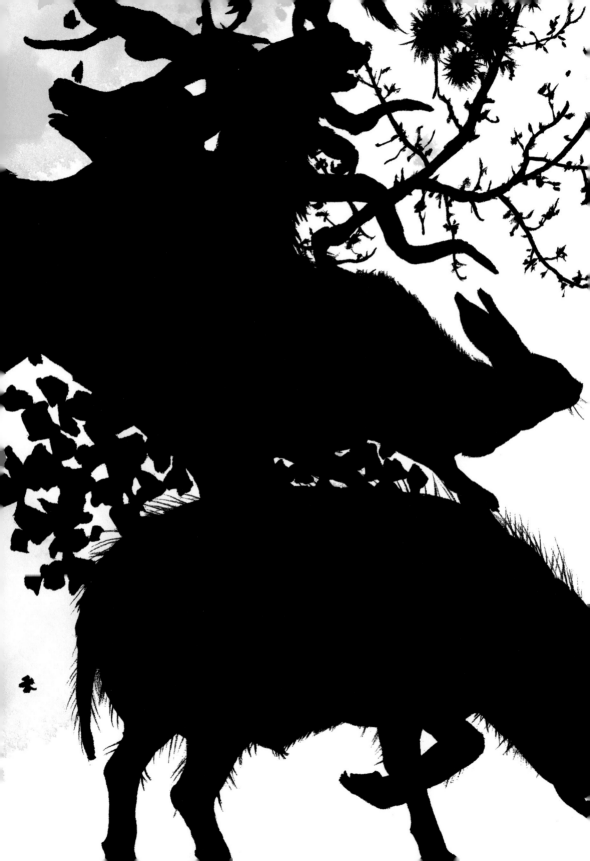

and holds her tail perfectly horizontally
as she trots, sign of—happiness, accomplishment?

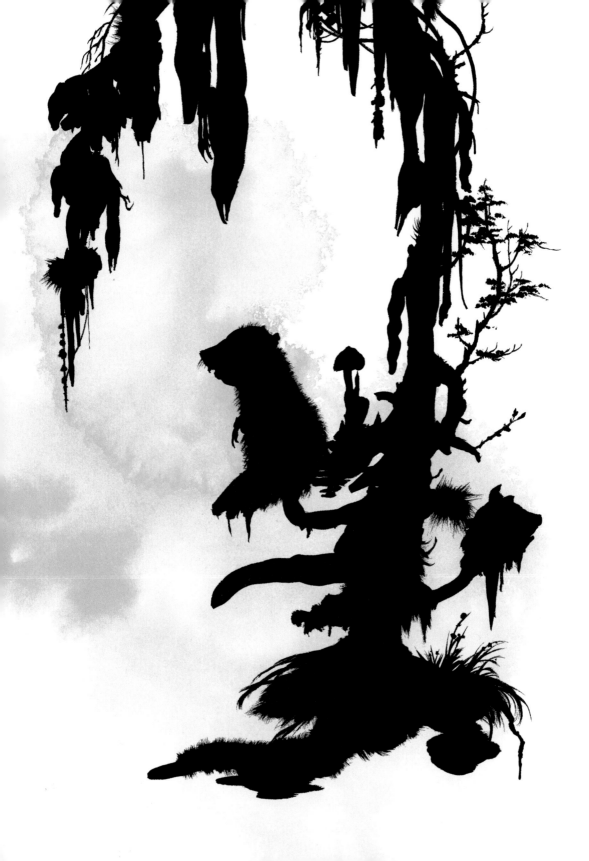

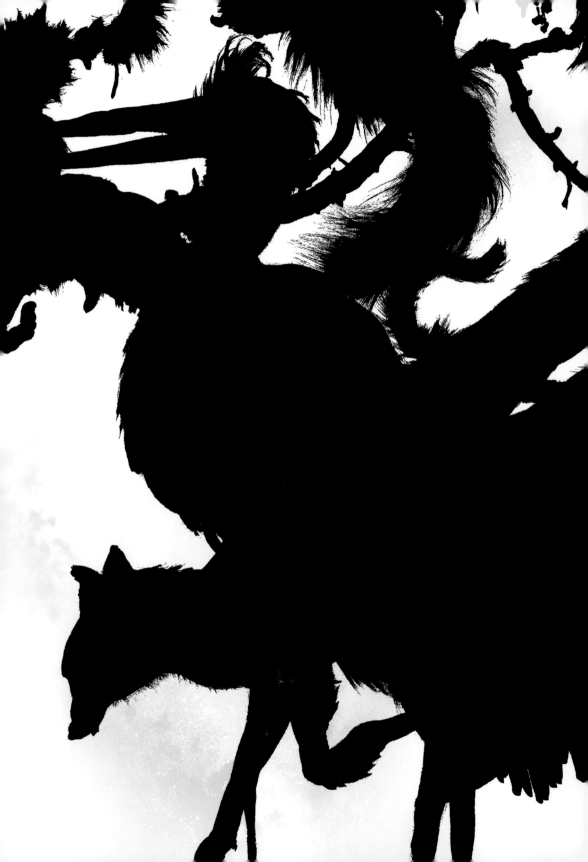

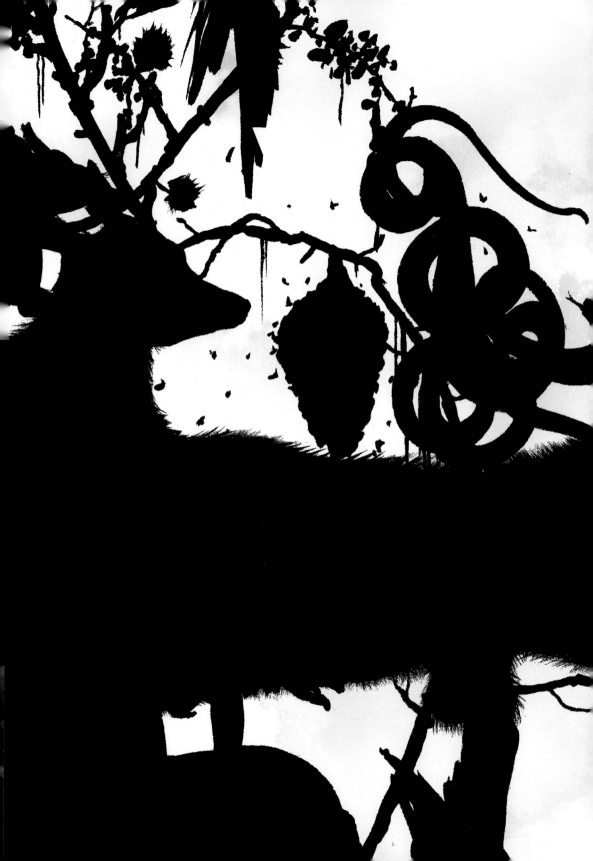

Snake

whose black and yellow signature
unscri*bb*ling itself across the path?

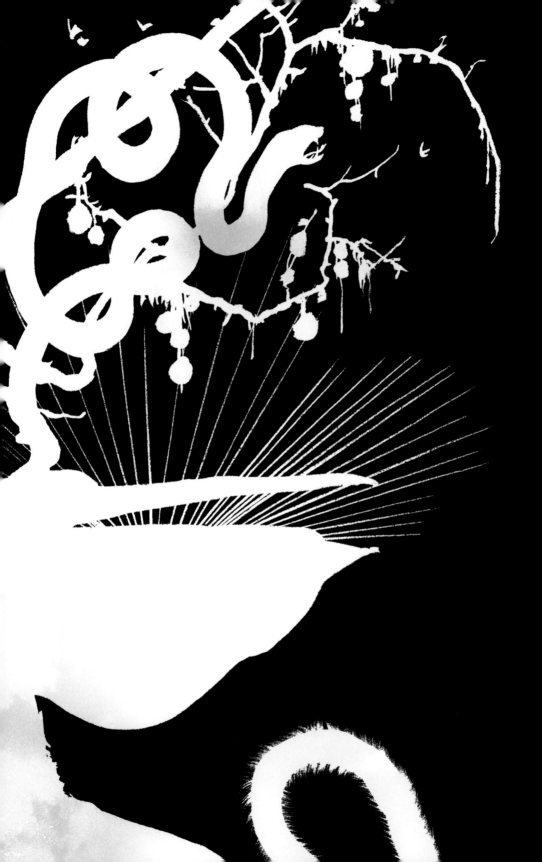

IT PERPLEXES ME that I can't describe
the sound *frogs* in the small pond make.

Three of them, this year, and each
strikes a single Japanese note in sequence,

some days, and then in the evening
comes the occasional, bolder _____.

What to call it? This ought to disturb us
more than it seems to. We've needed this *word*

for a thousand years and I cannot find it;
I am not convinced by *twang* or *croak*,

and this leads me to think that I don't believe
in *whinny* or *miaow*, *oink* or *arf*, though *plonk*
 and *growl* aren't bad.

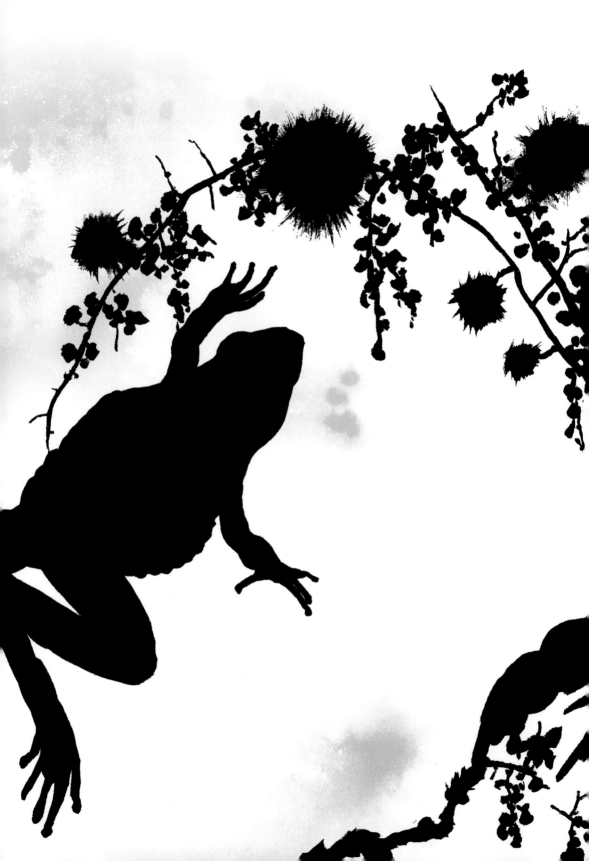

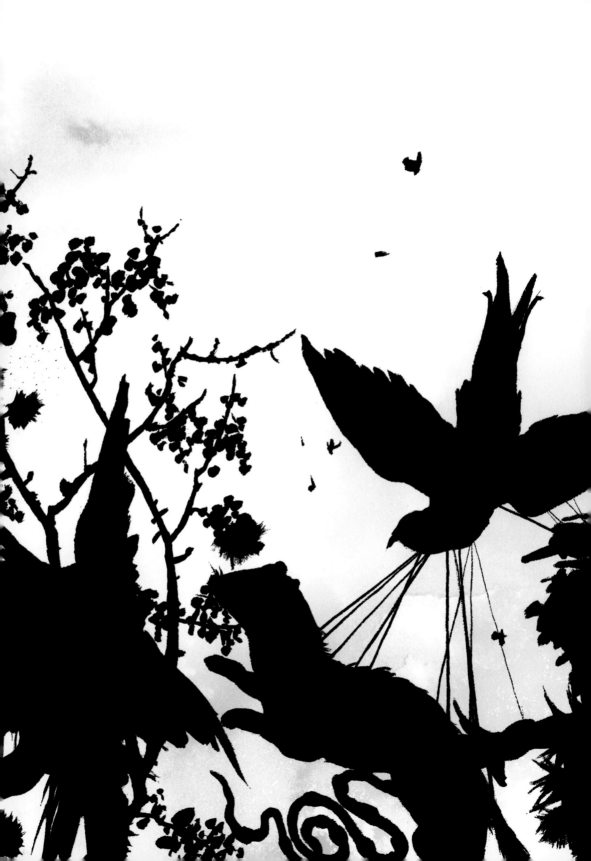

Our best words are for the birds
—because their *mu*sic charms us,

something more like our own?
Maybe they taught us to sing, and *therefore*

we say *trill* and *chorus* out of *k*inship,
as they embroider the dawn with arias and eruptions.

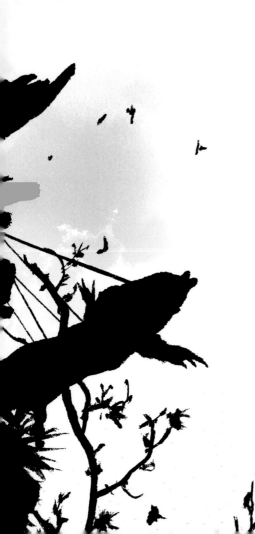

SLUG

who needs a *house* when you can make your own road

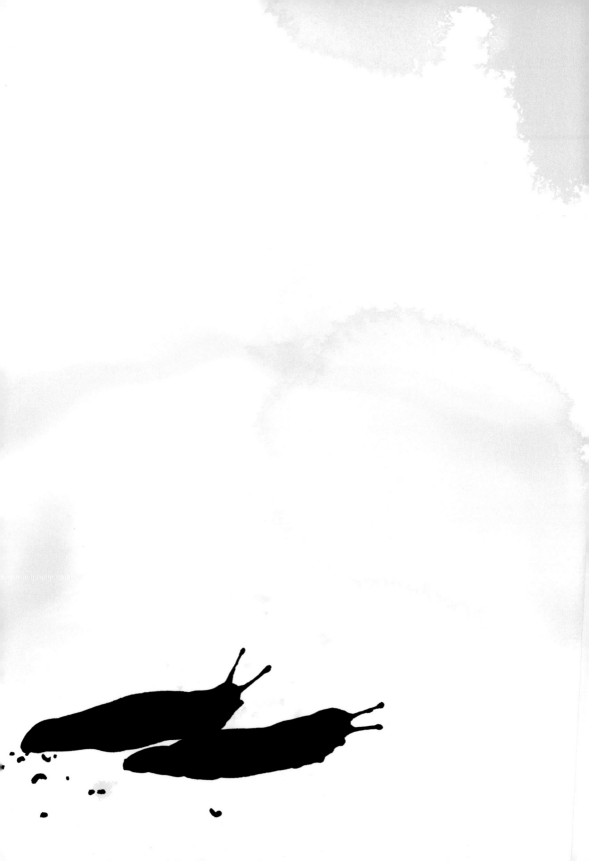

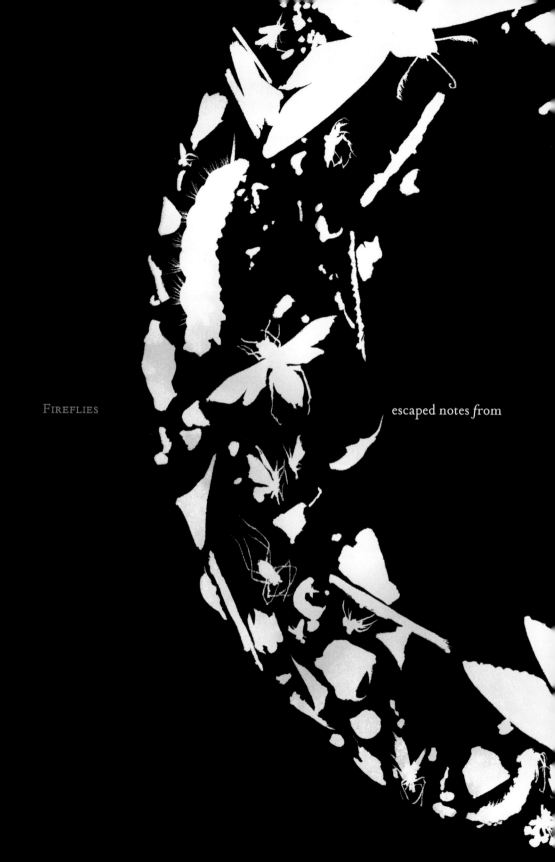

FIREFLIES escaped notes from

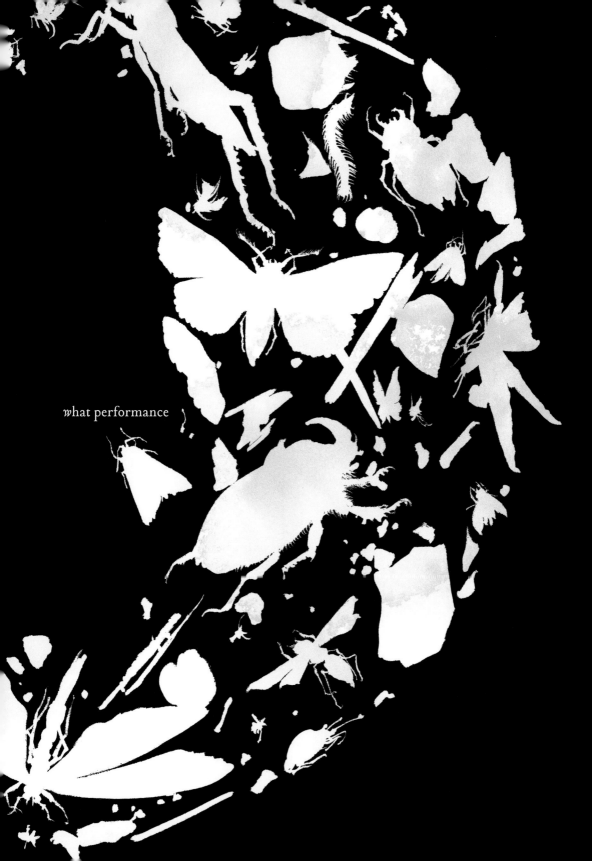

what performance

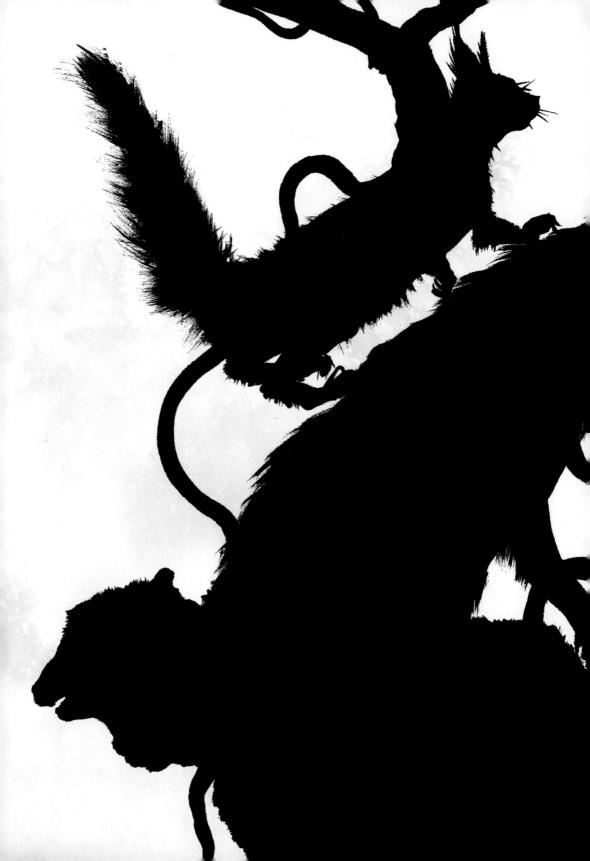

THE TINY RABBIT SUFFERING when Alexander found it,
on an April night in the garden, already beset by dogs.

so he, in kindness, with a tough and immediate clarity
that later startled him, crushed it beneath his boot.

Sudden quiet. The dogs a little bewildered.

Alexander telling the story, with a note of wonder
and of distance, as though someone else

had made that decision. He said he was trained,
as a boy, to do the difficult and practical thing.

I would sit beside the hapless creature miserably,
I might pray in some vague and tentative fashion,

and call my friend Carol, who is also a poet,
and tell her about it. Later, each of us

would write a poem about that sorry little fate;
all that feeling, it might as well be used.

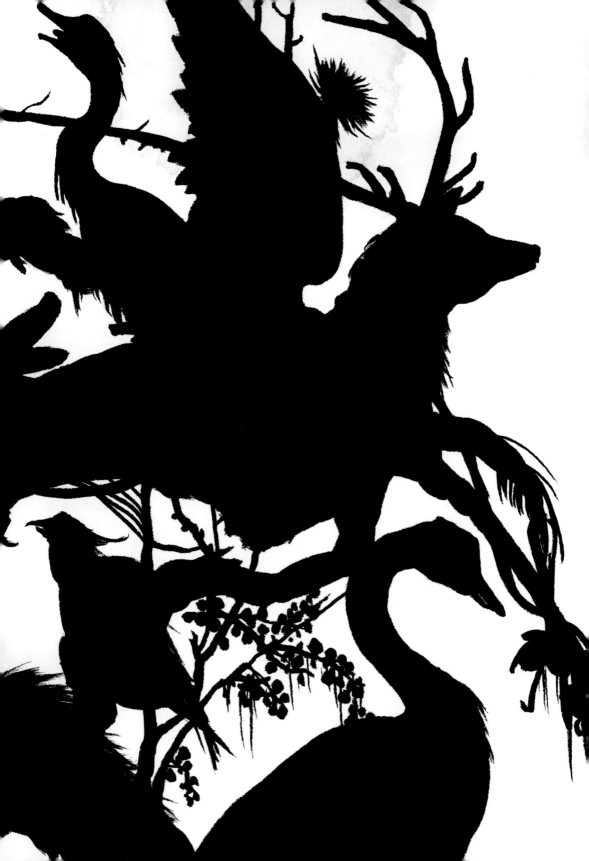

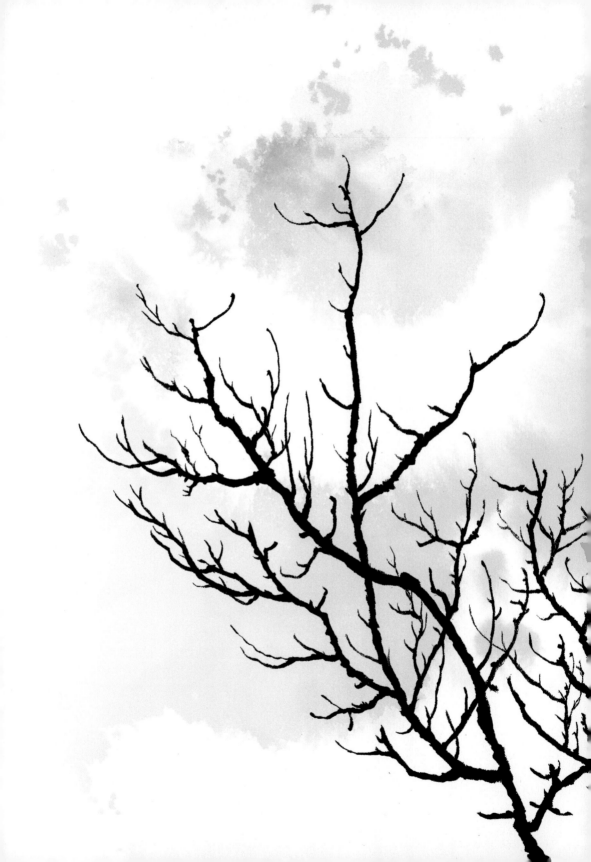

FOWLER'S TOAD: not the mellifluous chorus
of the peepers in *spring*, pleasing,
but a more headlong, unbridled _____.

I like to imitate it,
though I lose all dignity in doing so.

UP FROM THE DAMP LEAVES comes
the pale lamp of the firefly, fire balloon,
and the poet says, *Fragile lantern, fire balloon,*

as though the evening could not continue adequately
unless its parts were named.

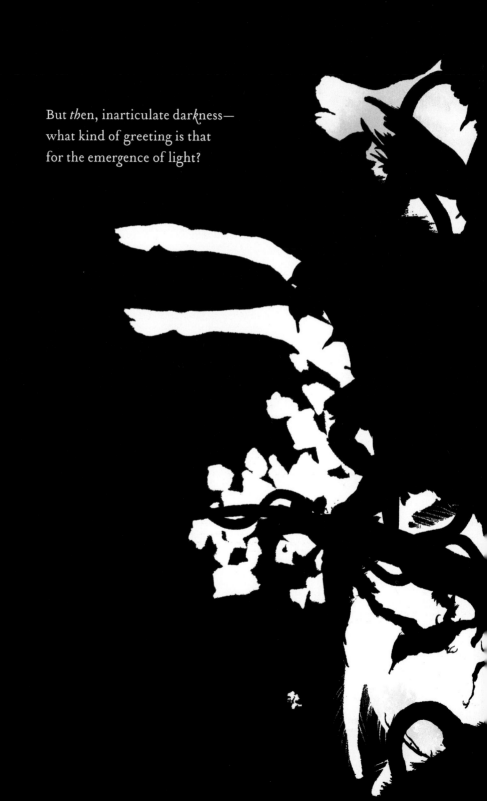

But *th*en, inarticulate dar*k*ness—
what kind of greeting is that
for the emergence of light?

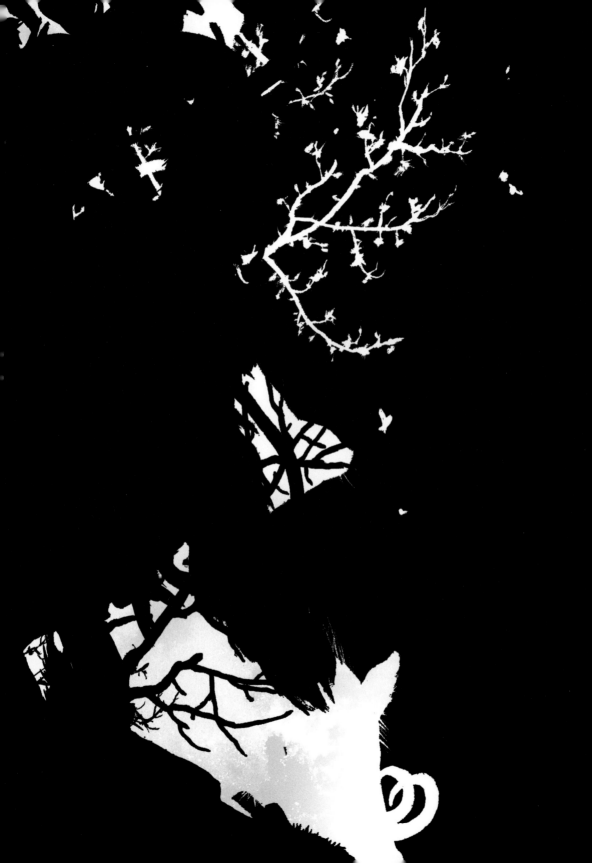

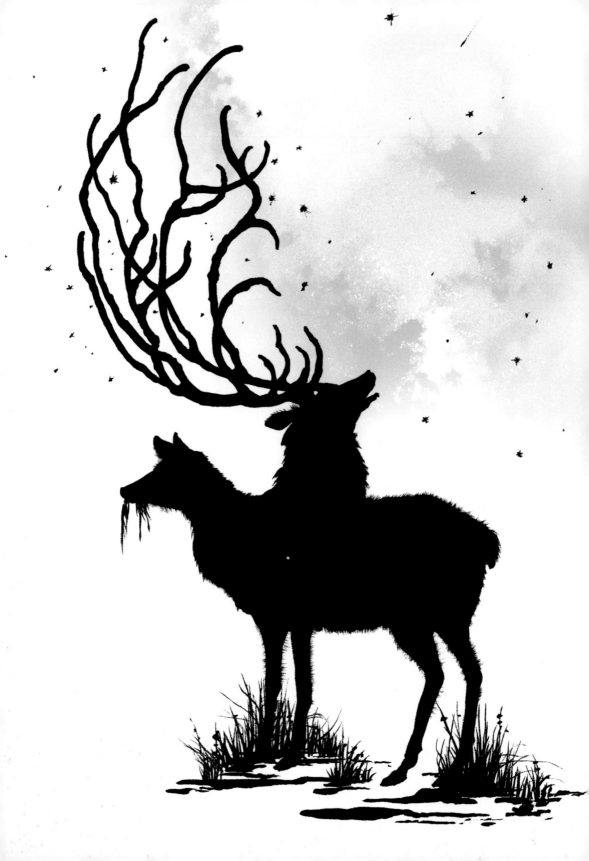

Box turtle: a hundred years to live
in a patch of woods, and here he is this morning
raising the mottled orange of his neck
delicately, lifting his beak
to a piece of last night's lettuce.

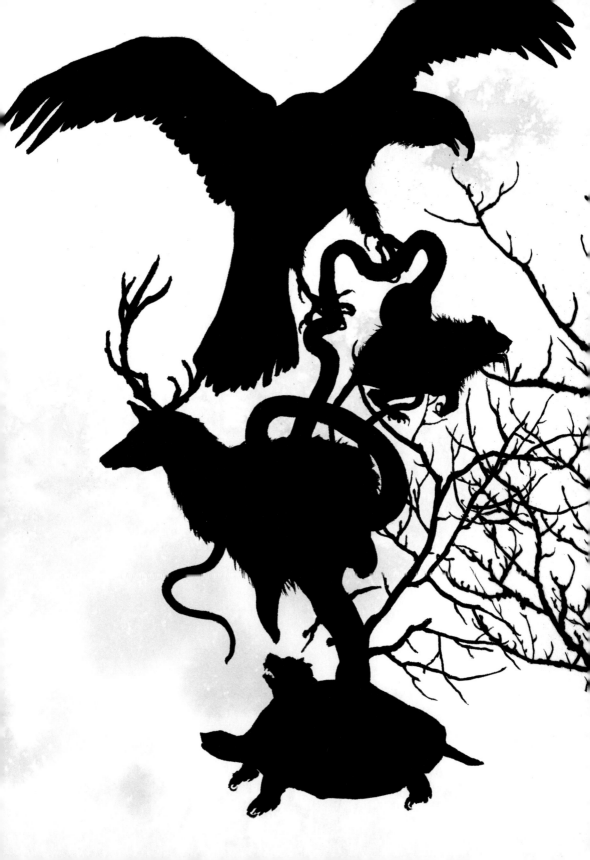

THE CICADAS issue

their repetitive summons;
the locusts imitate the lawn sprinklers of my youth.

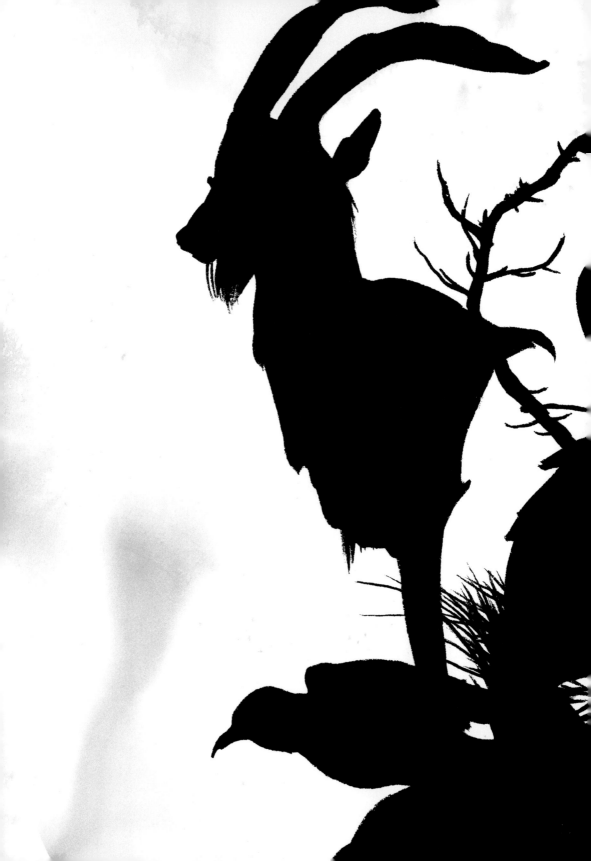

The neighbors' doomed goose cries from its pen;
she sees what's coming, but lacks
the consolation of philosophy.

SLUG (*ars poetica*)

Exposed I
must traverse
these inches
of earth—I

loved my dim-
mulch leaf-
shade dark
where I
lay shaded

till you
dropp'd me
into a glare
I'd never have
chosen,

my wet
blade-scraped,
luxury gleam
gone to dull—

Unprotected,
 though I can glide
on my own
gelled silver

—the self a road
By which the self

(carry no house carry nothing)

—progresses?
 Say
—defenseless—glides.

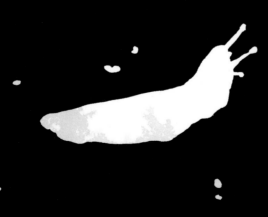

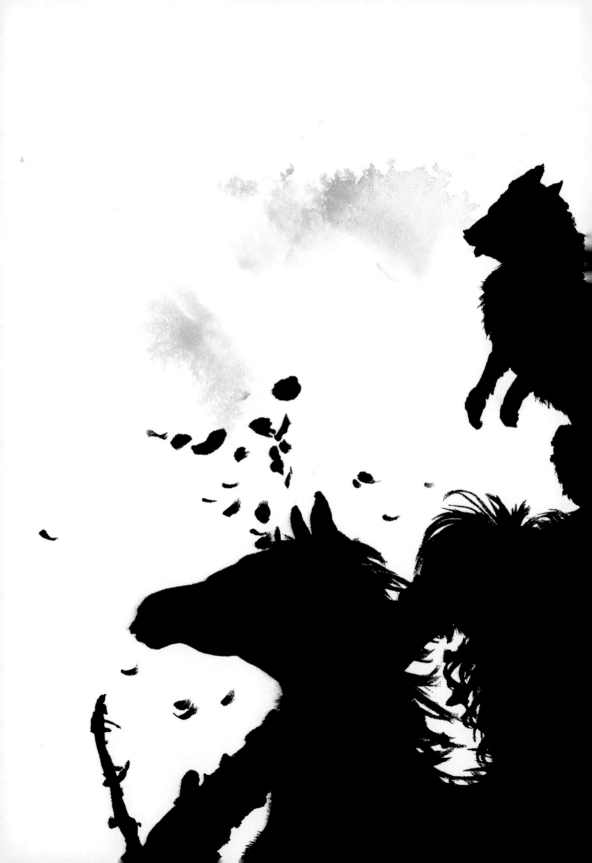

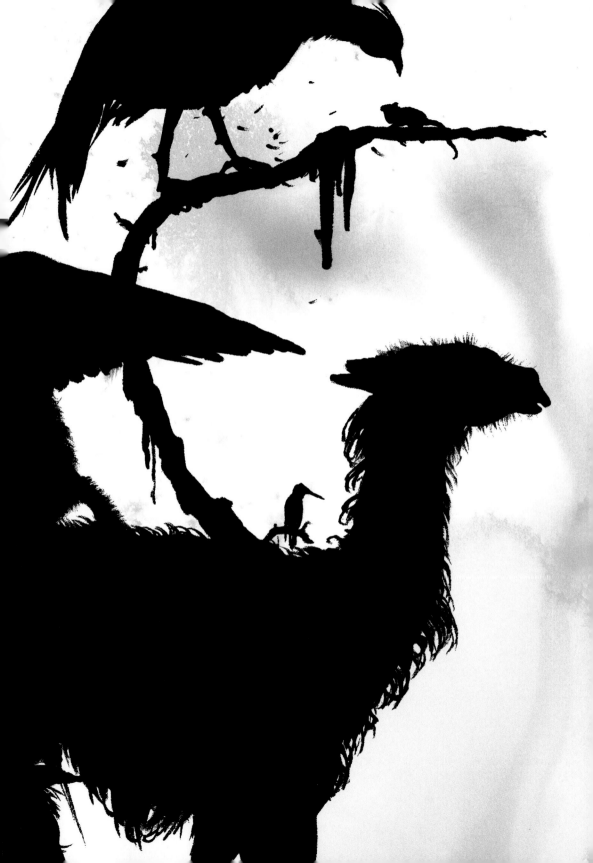

Rats tenured in the academy of hunger,
Each worm an *emperor of dissolution,*

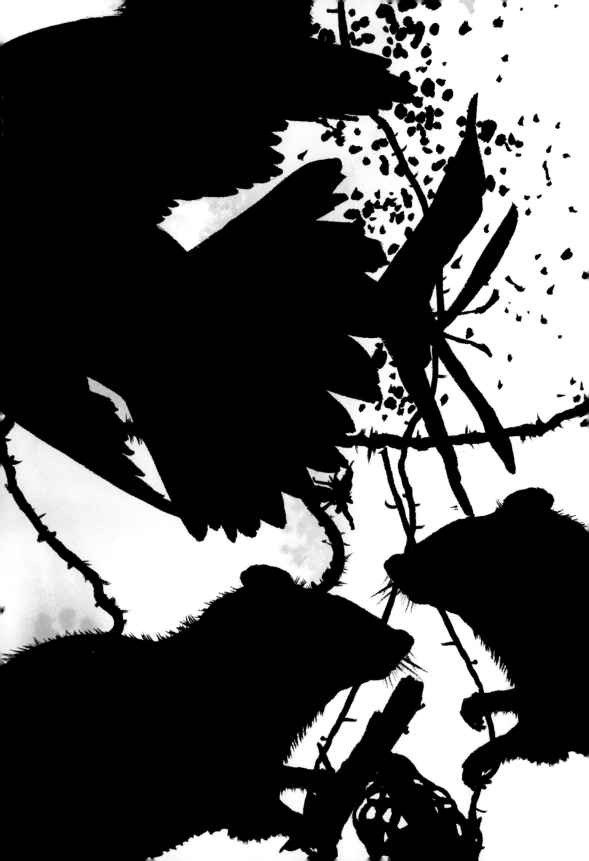

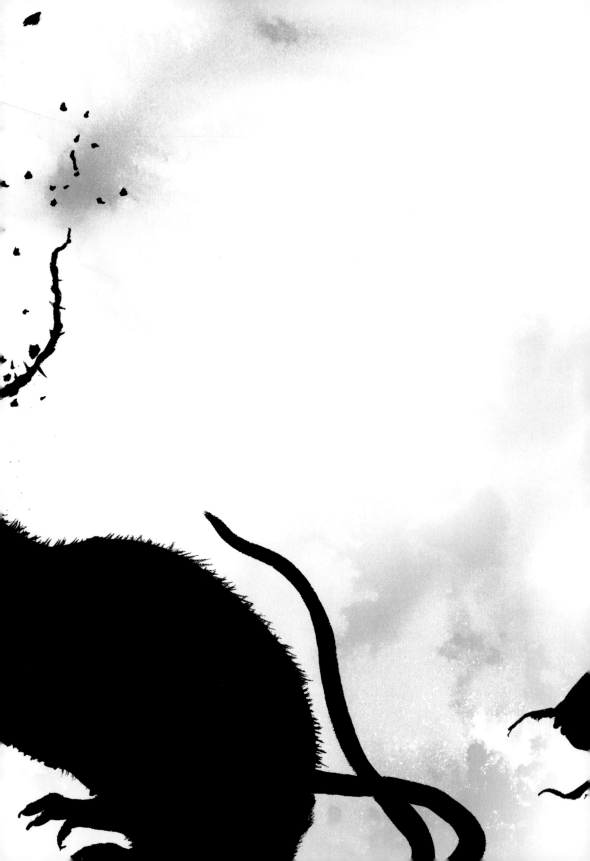

Every beetle a senator of the end.

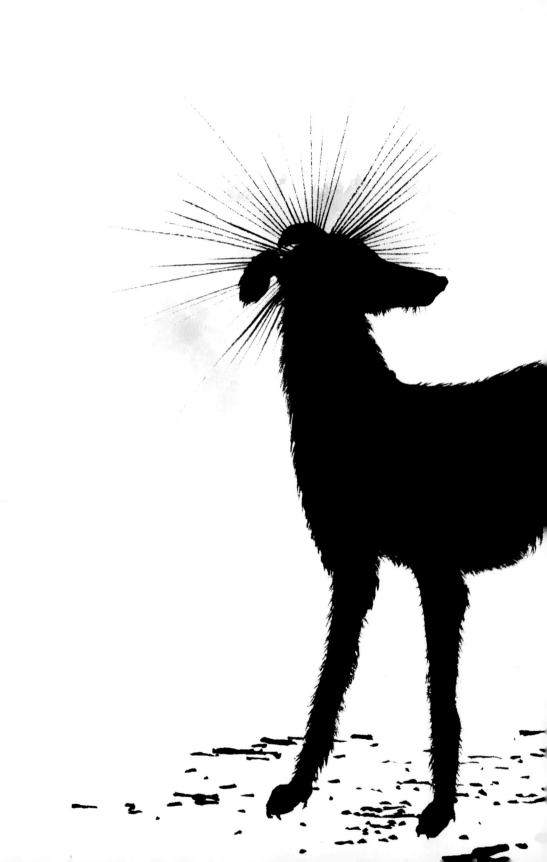

THE VERY DOMESTIC DOG, never more than a *few*
hundred feet from the men who care for him,

sits on the front lawn alone for a *wh*ile,
after the afternoon walk,

looking at the house across the road,
where for years ano*th*er dog barked at him

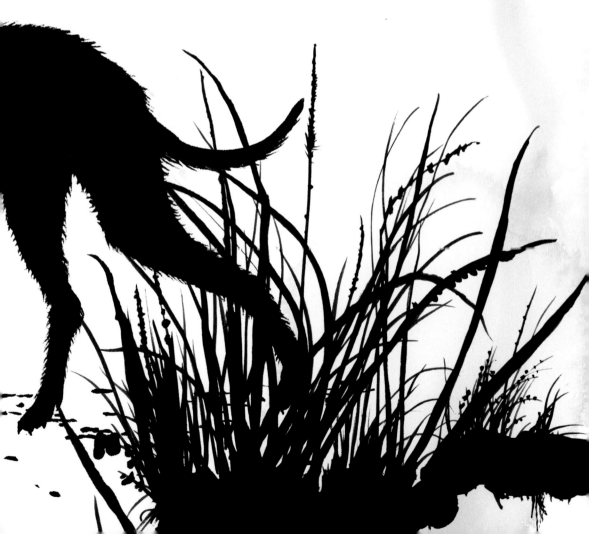

from behind her fence, in a tone perhaps plain*tive*,
perhaps *w*arning or invitation: *insc*rutable.

Silence now, the riddle never to be solved.
And he *st*udies the fenced, empty yard over there

as if, if he kept looking, he might see into
not just that que*st*ion, but the larger one.

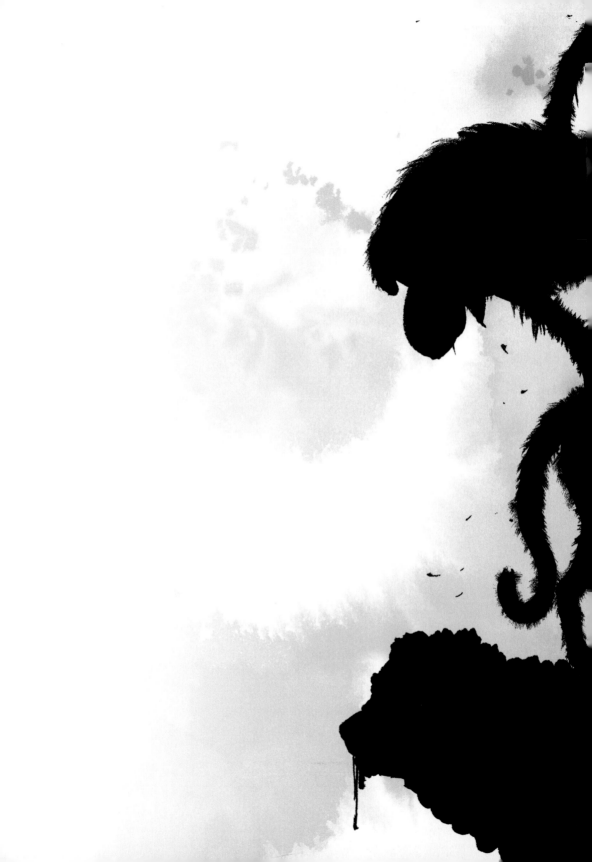

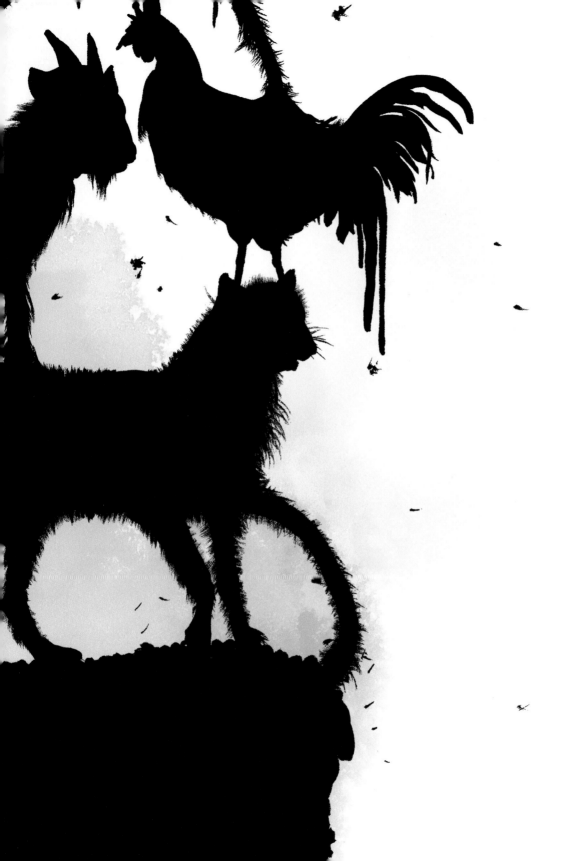

I STOP THE CAR, on Three Mile Harbor Road,
because a young box turtle is making his way

across our lane, and Alexander hops out
to help him. One SUV pulls up behind me,

then another, and soon the first
wants to pass me on the right,

so Alexander opens the passenger
door to block the way, and I raise my arm

to signal stop, and Alexander
scurries the little engine along *to*ward

the *w*ater side of the road. Later,
heading on into town, we look at each other

in a sudden wave of delight, having stilled
the ma*ch*ines, and thwarted the hur*ry*,

and sent some seven or eight ounces of life
on to the next *wh*atever, which is all anyone

can do for anyone else, *th*ough that
doesn't explain our joy.

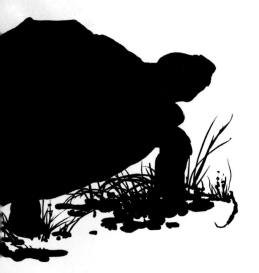

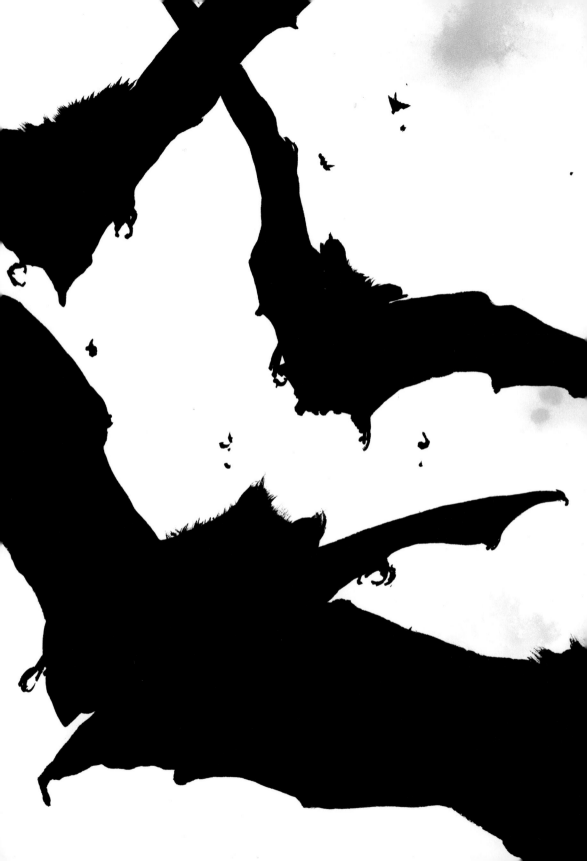

How TO TRANSLATE the little bats'
nearly inaudible peeping,

The body was made to disappear

Or
I slip into we so swiftly was I ever here?

Little bats stit*ch*ing up the dusk
with their superb crewelwork

ma*rk*ing the remaining hours
on an *ab*acus of stars

Bats who polish the gates of the *ex*it

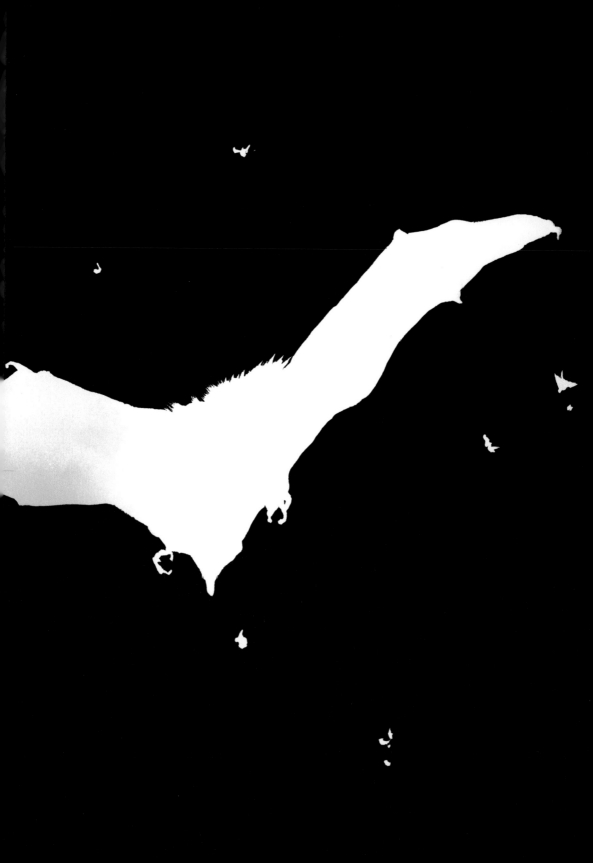

Horologists given the velvet key
to wind the night-spring
or not
as they choose

On *whose* watch the world is ending
ambassadors of the last perfect July
apostles of the la*te* summers

Hang upside down like us
in caverns and rafters in cool places
that treasure the evening
hold on to the night

And allow the darkness to close
your eyelids cool hand on your brow
and face wrap your arms around yourself
like wings be still be suspended

O what a world we owned

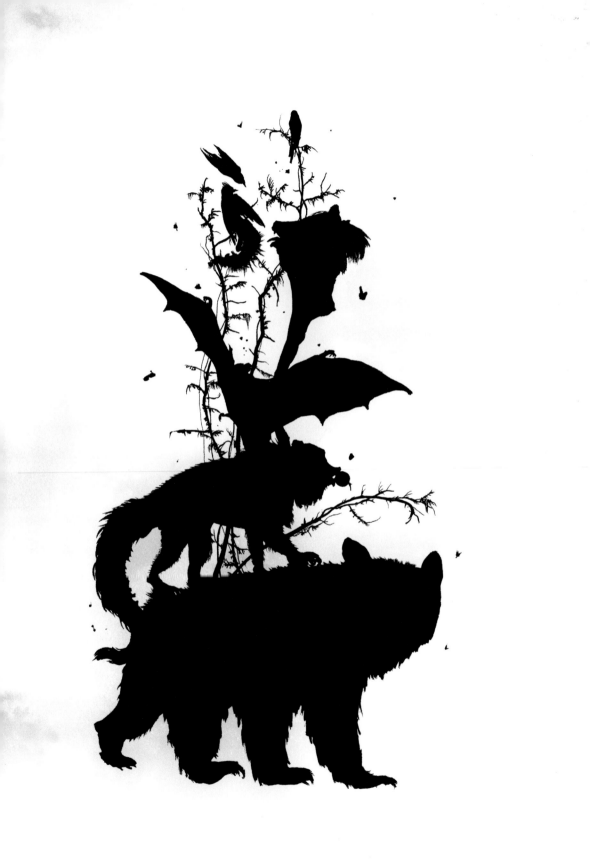

THE PEACOCKS
drag behind them
tattered curtains
of the summer palace—

exiles from a gone estate,
whether material or spiritual we have not
determined—

Hummingbirds, *routes of evanescence*—
and the anodized dragonflies,
and the shadowy catbird trapped in the berry net—

All day my work of naming goes on and on.

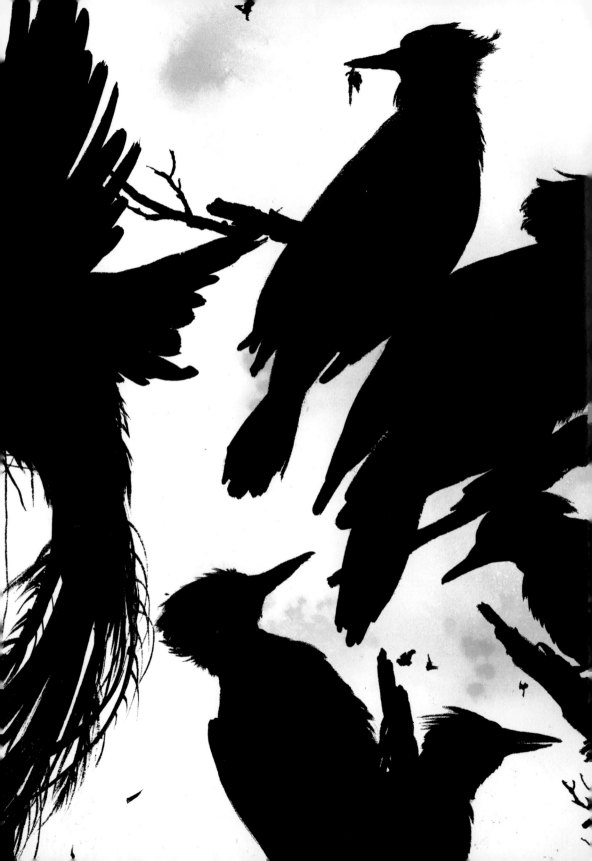

Now, one more thing:

*Car**d**inal*,
Orient *fl*ame—

Orient me!

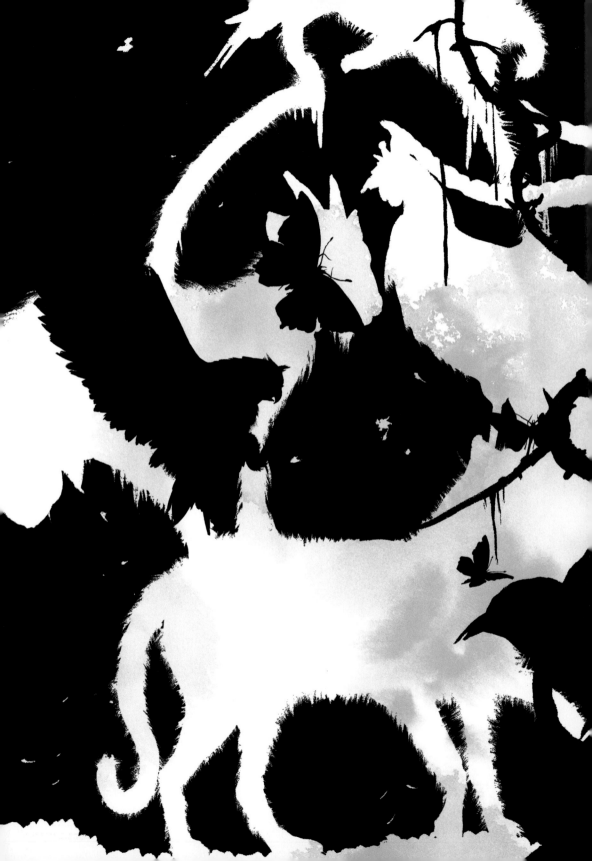

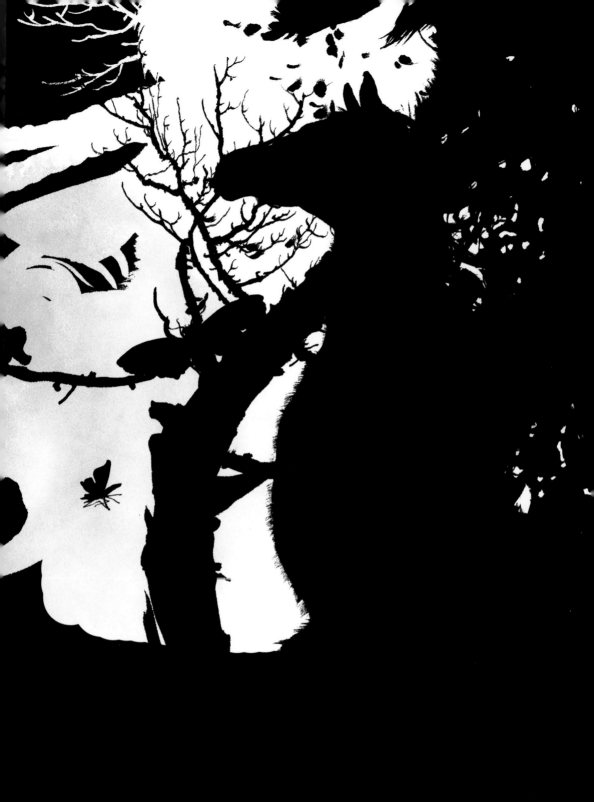

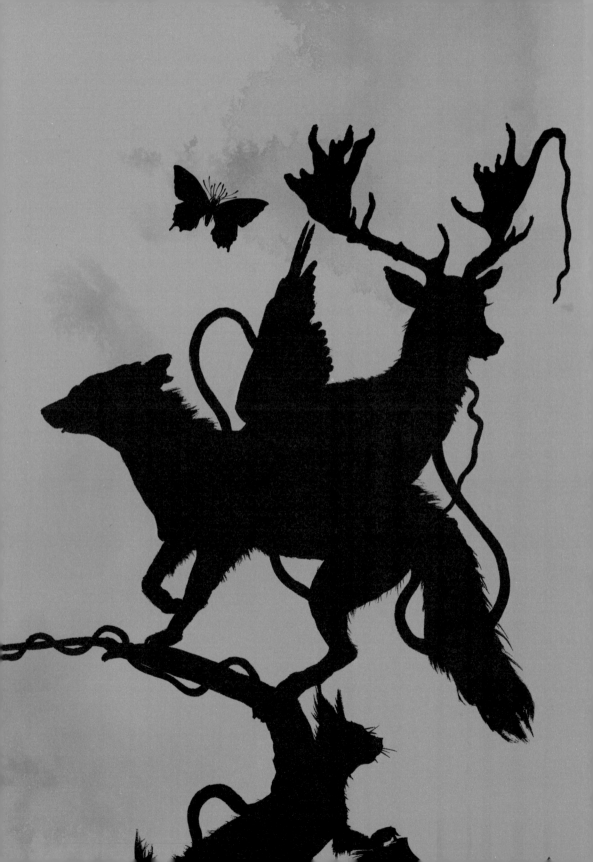

Afterword

WE ARE SURROUNDED BY A HOST, A SWARM, A FLOCK of instances of consciousness. We know, looking into a dog's face, that we're seeing the play of emotion, perception, a sentient being's reactions to experience. What about the other sorts of awareness around us? What is it to be a praying mantis, a field mouse, a starling, a rat hiding between the shadowy rails of the subway line? Perhaps we only know what it is to be human in contrast to something else.

But "in contrast" doesn't feel like quite the right way to describe our relationship to these other forms of life. My friend Anne, a Tibetan Buddhist, describes the fierce or tender gods who leer and beam from the sacred scrolls she studies not as images of deities external to herself but as incarnations of states of mind. Could one not, in this way, find one's inner cricket, or that aspect of oneself that deeply identifies with the hungry, dedicated goat, or the patient heron studying a pond for the least glimmer of fish? One thing animals are for us is a set of possibilities, a way of describing who we are.

Years ago, when I was interested in reading tarot cards, I learned to view the images of the most important cards, the Major Arcana, in the same way; the Fool about to walk blithely off the edge of the cliff or the lightning-struck Tower might be understood as emblems depicting moments in the life of the soul. Darren Waterston's beautiful and

discomfiting pictures of animals—morphing into one another, stacked up, growing out of each other's bodies—strike me in the same way. His animals are both themselves and metaphors for us, at the same time other and deeply familiar.

And that may be the deepest secret of these creatures' appeal: they are like us, in their appetites, their foibles, and their mortality, and yet they bear hooves or tails, eyes that gleam green or red in the dark, or horns. We see ourselves in them, even though they are winged or covered in shining fur.

This is the source of a kind of shivery delight, as well as the wellspring of allegory. We love to see animals as extensions of ourselves, as all those old prints of card-playing dogs prove; they are ready to be annexed, seen as versions and mirrors of ourselves, and we laugh to see ourselves reflected.

There's a famous passage in "Song of Myself" where Walt Whitman practiced this use of animal as moral emblem. Its opening line is lovely and deeply memorable. "I think I could turn and live with animals," he writes, giving voice to a sentiment every human being seems to feel at times: the wish to be free of the folderol and claptrap of humanity, to dwell in some more elemental fashion. But look where the poem goes from there:

> . . . they are so placid and self-contained,
> I stand and look at them sometimes half the day long.
>
> They do not sweat and whine about their condition,
> They do not awake in the dark and weep for their sins,
> They do not make me sick discussing their duty to God,
> Not one is dissatisfied . . . not one is demented with the
> mania of owning things,
> Not one kneels to another nor to his kind that lived
> thousands of years ago,
> Not one is respectable or industrious over the whole earth.

That is a wonderful passage, but after "they are so placid and self-contained" (which is not, in fact, true, save perhaps of cattle, and even then I don't know that I believe it), it is not in fact about animals but instead a critique of human failings. This illustrates just how difficult it is for even a master poet to write about animals as animals, and just how swiftly they lend themselves to an examination of the human condition.

Philip Levine titled one of his great poems from the 1970s "Animals Are Passing from Our Lives." A little more than a hundred years ago, most people in the developed world lived in far closer proximity to a variety of animals than they do today. My mother, who was born in eastern Tennessee in 1920, employed all her life a variety of figures of speech that had been born out of direct observation of the creatures she and her family knew intimately. A quick action might be said to be "faster than a hen on a june bug," for instance, or the dark sheen of an iron skillet used mostly for making corn-bread would be described as black as the hindquarters of a "jenny," a female mule. Animals provided detail and metaphor; their presence enlarged both the world and the language used to describe it. It's not accidental that the first poet in English whose name we have, Caedmon, worked in a stable, and received his vocation from a tutelary angel who taught him to sing there in the barn. The beasts around him may have been "dumb," but surely their noises and their silences fed the poet's inspiration and fueled his need to sing. We separate ourselves from animal company at our peril; we are dimin-ished without them. And needless to say the world around us is diminished as we drive them farther away; just how diminished, and how endangered, we probably have yet to learn.

But that warning makes me want to touch on another aspect of our relationship with our fellow creatures. We take a sheer, fundamental pleasure in their being, and for all its gothic mood and allegorical edge, that's a crucial aspect of Darren Waterston's work, too. He delights in the shape of the moth, the long line of the dog's spine, the archaic elegance of the peacock. To be around animals makes us happy, and who can say why? Even C. P. Cavafy, a poet who generally betrayed not a shred of sentimentality, and whose greatest poems are dry, clear-eyed evocations of experience that

cannot be retrieved save through the agency of the poem that tries, for its moment, to contain memory and desire—well, even he could be swayed, as what is perhaps his warmest and most relaxed poem evidences. This is Daniel Mendelsohn's translation of Cavafy's "House with Garden" of 1917:

> I wanted to have a house in the country
> with a very large garden—not so much
> for the flowers, the trees, and the greenery
> (certainly there will be that, too; it's so lovely)
> but for me to have animals. Ah to have animals!
> Seven cats at least—two completely black,
> And for contrast, two white as snow.
> A parrot, quite substantial, so I can listen to him
> saying things with emphasis and conviction.
> As for dogs, I do believe that three will be enough.
> I should like two horses, too (ponies are nice).
> And absolutely, three or four of those remarkable,
> those genial animals, donkeys,
> to sit around lazily, to rejoice in their well-being.

To be "creaturely" is perhaps to be capable of just that, rejoicing in the body, in the physical delight of being. It is one of the gifts the animal kingdom offers us—to be brought back to our own bodies, to our joy in the present, our pleasure in being here. May this book contribute, in any way it can, to that pleasure, and to the value we place on the creature-world around us.

Mark Doty

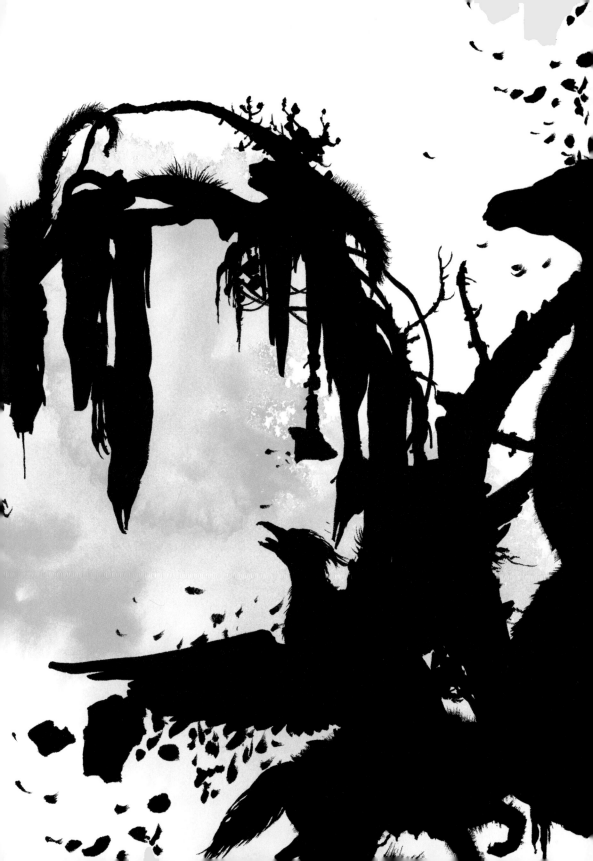

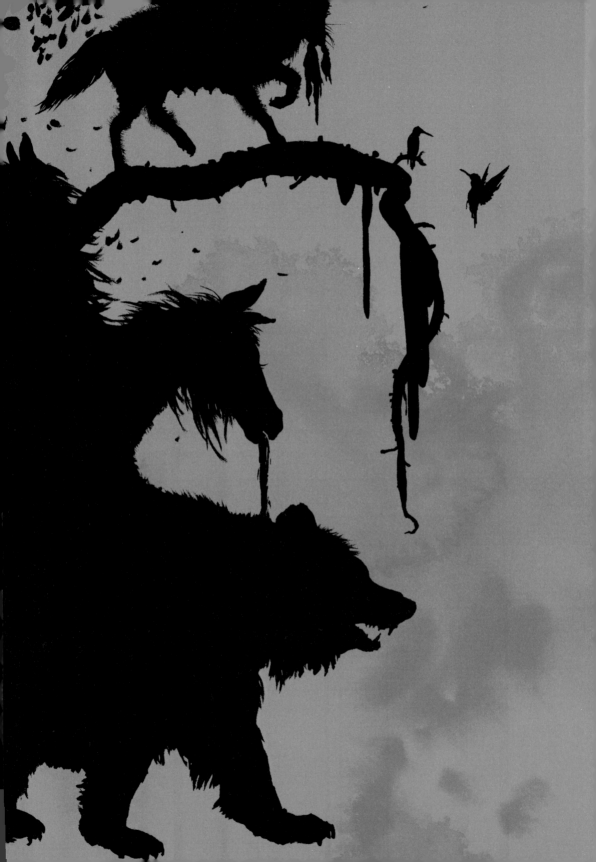

Acknowledgments

I HAVE BEEN DEEPLY ENGAGED WITH THE BOOK as an art form for some time now. For as long as I can remember, I have contemplated, collected, and even constructed books. As a college student in Germany, I apprenticed at an archive museum where I learned restoration and binding of early books and illuminated manuscripts. It was there that I first discovered the medieval bestiary.

The bestiary is both a literary and an illustrative form in which a finite number of known species—as well as mythological creatures—are catalogued encyclopedically. As a genre, the medieval bestiary not only constituted a natural history of creation but also participated in the rich tradition of the moralizing allegory, with the animal kingdom providing apt symbols for human behavior, folly, and the postlapsarian condition. The bestiary has had a long life outside the medieval context, however, with artists and writers from Henri de Toulouse-Lautrec to Pablo Neruda approaching the form with spirited inventiveness.

Three years ago, Karin Breuer, a curator at the Fine Arts Museums of San Francisco, asked me to participate in what she hoped would become an ongoing series of fine press projects commissioned by the Achenbach Graphic Arts Council. The idea was to bring together a visual artist and a writer to create a small-edition graphic project culminating in a portfolio of prints and broadsides. I had already been researching bestiaries and working on related drawings, so Karin's invitation gave me the perfect opportunity—

as well as the honor and pleasure—to explore the idea further. It was Barbara Pascal, a dealer of artists' books and a close friend, who urged me to ask one of my favorite contemporary writers, Mark Doty, to collaborate on the project. Barbara introduced me to Mark's poetry in the early 1990s, and she knew that since then I have read almost everything he has written. When I worked up the nerve to contact Mark, he obliged with a long, engaging visit and soon agreed to participate. We began at once to imagine *A Swarm, a Flock, a Host*—a compendium of birds, beasts, and bugs that inhabit both the real world and the mind's eye.

As Mark's extraordinary poetry took form, I painted in response, inspired by his words though not directly illustrating them. For our modern-day bestiary, I chose to use silhouetted animal and plant forms to evoke a fairy-tale narrative and illustrate states of metamorphosis, dematerialization, and epiphany. I depicted the animals in emotionally charged configurations that are meant to be as menacing as they are playful.

The creatures' bodies are in a state of transition, in flux and without boundaries. I wanted the animals to assert their precisely described particularities even as they surrender the limits of their bodies. By turns monstrous, fanciful, and abstract, the composite forms breed strange fellowships between species normally separated by geography and time as well as by the line between fact and fiction.

I would first like to thank Karin Breuer and the Achenbach Graphic Arts Council for making this project possible. Thanks are also due to Karen Levine, executive editor at Prestel, for all her enthusiasm and steadfastness in realizing this book; to Jennifer Sonderby for her beautiful, thoughtful design; and to Nicole Miller for managing the portfolio project from beginning to end. I owe special appreciation to Barbara Pascal for being the first to introduce me to the work of Mark Doty, and heartfelt thanks to Mark himself for sharing with me "a bit of the original flame."

Darren Waterston

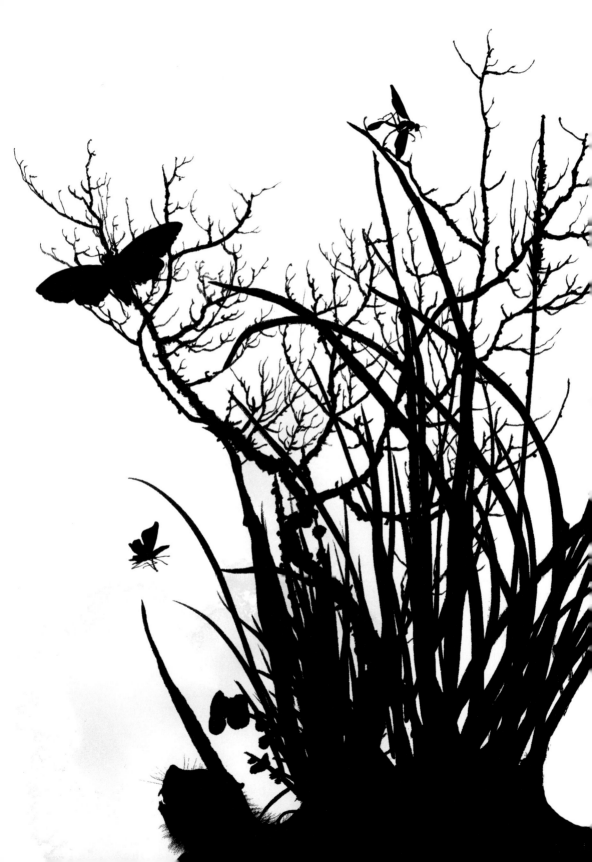

© 2013 Prestel Verlag, Munich • London • New York
Text © 2013 Mark Doty
Artwork © 2013 Darren Waterston

Published by Prestel, a member of Verlagsgruppe Random House GmbH

Prestel Verlag
Neumarkter Strasse 28
81673 Munich
Germany
Tel.: +49 89 41 36 0
Fax: +49 89 41 36 23 35

Prestel Publishing Ltd.
4 Bloomsbury Place
London WC1A 2QA
United Kingdom
Tel.: +44 20 7323 5004
Fax: +44 20 7636 8004

Prestel Publishing
900 Broadway, Suite 603
New York, NY 10003
Tel.: +1 212 995 2720
Fax: +1 212 995 2733
E-mail: sales@prestel-usa.com

WWW.PRESTEL.COM

LIBRARY OF CONGRESS CATALOGING-IN-PUBLICATION DATA

Doty, Mark.
 A swarm, a flock, a host : a compendium of creatures / Mark Doty and Darren Waterston.
 pages cm
 ISBN 978-3-7913-4757-8
 1. Waterston, Darren, 1965-–Themes, motives. 2. Animals in art.
 I. Waterston, Darren, 1965– II. Title.
 ND237.W3539D68 2013
 759.13—dc23

 2012035897

EDITORIAL DIRECTION
Karen A. Levine

DESIGN
Jennifer Sonderby, Sonderby Design

PRODUCTION
The Production Department

SEPARATIONS
Fine Arts Repro House, Hong Kong

PRINTING
Midas Printing International, Dongguan, China

Verlagsgruppe Random House FSC-DEU-0100
FSC-certified 135gsm Gardapat Kiara 1.3 FSC matte supplied
by Cartiere del Garda, S.p.A., Riva del Garda (TN), Italy

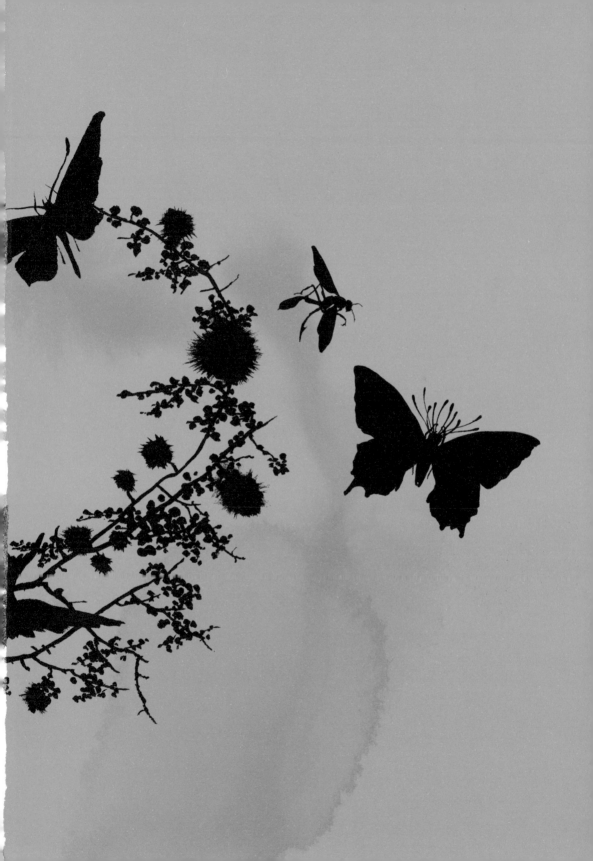

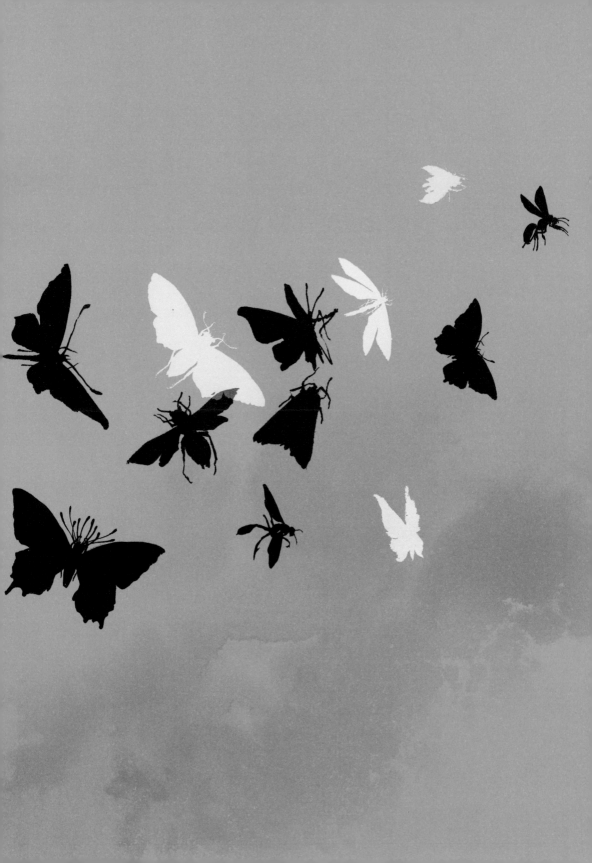